I0573962

Michael Landy
Semi-detached

ex libris
Karsten Schubert

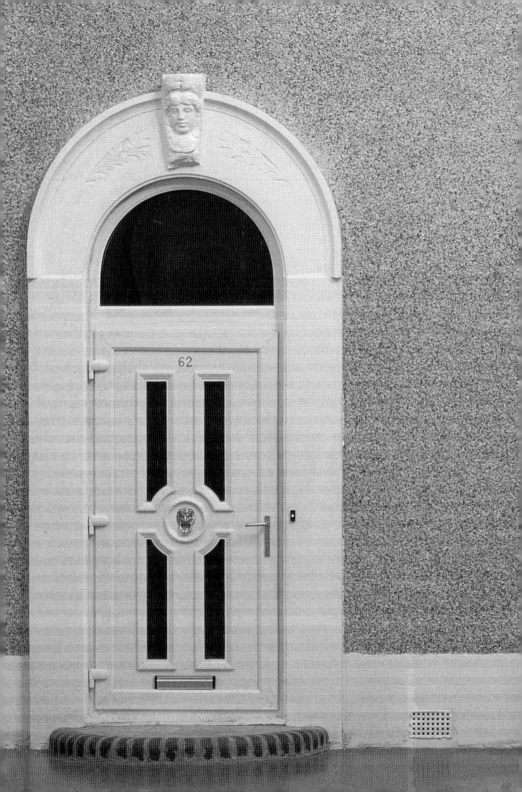

Michael Landy
Semi-detached

**With essays by
Judith Nesbitt and John Slyce**

Tate Publishing

First published 2004 by order of the Tate Trustees
by Tate Publishing, a division of Tate Enterprises,
Millbank, London SW1P 4RG
www.tate.org.uk/publishing

On the occasion of the exhibition at
Tate Britain, London, 18 May –12 December 2004

Supported by Tate Members, with additional
support from The Henry Moore Foundation, Karsten
Schubert, Thomas Dane, and Alexander and Bonin

© Tate 2004. All rights reserved.
Works by Michael Landy © The artist.

British Library Cataloguing in Publication Data
A catalogue record for this publication is available
from the British Library

ISBN 1 85437 535 0

Distributed in the United States and Canada by
Harry N. Abrams, Inc., New York

Library of Congress Cataloguing in Publication Data
Library of Congress Number 2004102506

Printed and bound in Great Britain by BAS Printers,
Salisbury, Wiltshire
Designed by Gary Stillwell and William Hall
www.williamhall.co.uk

Contents

Foreword

Michael Landy's *Semi-detached* is the latest in a long-running series of special commissions for the Duveen Galleries – that remarkable space for the display of art that forms the central spine of Tate Britain's building at Millbank. It is the artist's first major installation since *Break Down*, the renowned project that took place in 2001 in a former high street department store in central London, and his first representation at Millbank since the display of *Scrapheap Services* (acquired by Tate, 1997) in 1999. Widely acknowledged as one of Britain's leading artists since the 1990s, Landy's work is often daringly personal. *Semi-detached* is an extraordinary conception, poignant in subject and visually astonishing; we are grateful indeed to Michael for taking on this commission with such characteristically unsparing commitment. The project has been curated by Judith Nesbitt (Head of Exhibitions and Displays at Tate Britain) and Carolyn Kerr, assisted by Lizzie Carey-Thomas; it has been a formidable team. To them, to Michael, to those who have contributed vital financial support (Tate Members, The Henry Moore Foundation, Karsten Schubert, Thomas Dane, and Alexander and Bonin), and to those who made and installed the work (Mike Smith Studio and the Tate art handling team), many thanks.

Stephen Deuchar
Director, Tate Britain

Artist's Acknowledgements

Michael Landy would like to thank Carolyn Alexander, Ted Bonin, Thomas Dane, James Lingwood, Helen van der Meij, Saint Barbara, Clive Lissaman, Kiki Patsali, Maureen Paley, Karsten Schubert, John Slyce, David Cunningham, Liv Pennington, Anna Nesbit, Mikei Hall and the Tate art handling team, Ray Burns, Andy Shiel, Stephen Deuchar, William Hall, Judith Severne, Sophie Lawrence, and John Hansen.

At Mike Smith Studio: Katie Beeson, Nick Bourne, Mark Cannon, Bo Droga, Gregor Eiden, Tim Griffin, Andy Hsu, Alex Kneller, Tobias Ingels, Gavin Morris, Chris Shanck, James Shearer, Kris Stringer, Fraser Sharp.

For *Shelf Life*: Justin Pentacost, Mitch Spooner, Crispin Larratt; Matt Suddaby and Larry Hurt at Arri Media; Chris Allen, Darren Christie, Ziggy Zigouras, Richard McKeand and Kenny Gibb at The Moving Picture Company. Special thanks go to Caroline Slade, the Producer of *Shelf Life*, Natasha Braier, Director of Photography for *Shelf Life*, and Kathy Kenny, Editor of *Four Walls* and *No.62*.

And finally special thanks to Lizzie Carey-Thomas, Carolyn Kerr, Judith Nesbitt, Mike Smith, Gillian Wearing, and Ethel and John Landy.

'Everything must go'
Judith Nesbitt

In 2001, Michael Landy won both praise and opprobrium when, during a two-week period, he and a team of workers disassembled, pulped and shredded all his possessions in the former C&A shop premises on Oxford Street, London. The destruction was witnessed by shoppers, who strolled in with their own newly bagged purchases. Love letters, Saab car and valuable artworks all underwent the same fate. The final piece to go, Inventory number C714, was the one to which Landy was most attached – his father's old sheepskin coat. Like everything else, it made the circuit of the conveyer belt 'production line', awaiting its inevitable disintegration and dispatch. 'I'm going to kill the operative who destroys my dad's coat', he remarked at the time, perhaps only half joking.

The coat was duly shredded, completing an extraordinary act of reduction: all the paraphernalia of material existence was subtracted from a life. It was a courageous and radical act that challenged the normality of contemporary consumerism. It was also, according to Landy, a euphoric experience: 'This is a celebration of a life, but I'm still alive. People come in who I haven't seen for years. It's really nice. I'm happy every day. It's like my own funeral, but I'm alive to watch it.'[1] A performative art work, this controlled act of dematerialisation directly addressed its audience: high-street shoppers and art-world denizens alike. It was saved from the danger of sanctimony, however, by the sheer self-exposure required of Landy himself. He was doing this for real, in a systematic, uncompromising

Detail from *Break Down* 2001

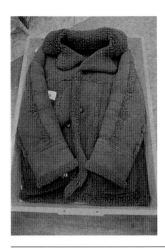

way. He wasn't taking a vow of life-long penury, but he did, over a two-week period, radically transform his life. Taking away one of the most pervasive predicates of contemporary human existence, *Break Down* – however temporarily – detached 'I am' from 'I have'.

Friends, critics and commentators wondered what Landy would do next. Though he has always maintained a drawing practice (and has, since *Break Down*, also produced a series of etchings), his fifteen-year career has centred on ambitious large-scale projects, which typically take two to three years to realise. The stark finality of *Break Down* made it seem a point of no return: wouldn't any further production undo its eloquence?

The sheepskin coat was a clue as to where Landy would go next. He wondered at the time of *Break Down* what impact destroying the coat would have on his father, who had bought it just before suffering a serious mining accident. It was too heavy and uncomfortable for Mr Landy to wear thereafter, though his wife was obliged to continue the repayments for a year. As a symbol of his father's life, it proved to be the starting point for a new project, which the artist had been thinking about for some time. Like *Break Down*, *Semi-detached* is a forensic examination of a life radically transformed: in this case, his father's. Here, however, the aspect of identity in question is not possession – 'I have' – but ability – 'I can', and 'I was'. The new work is neither documentary nor biography, though it contains aspects of both. It is an artifice, a constructed art work, like everything else Landy has done; but at its centre is a deeply observed individual human subject.

On 21 July 1977, aged thirty-seven, John Landy, a miner, suffered severe injuries when a tunnel roof collapsed on his head

and shoulders. He remembers glimpsing the roots of trees above his head as the earth fell in. His back was broken and the many chronic injuries he suffered have resulted in disability and a continuing dependence on strong medication. John Landy was typical of generations of immigrant Irish working men, content – proud, even – to spend a lifetime doing the hard dirty labour most people would flinch from undertaking even for a day. So attached was he to his work that after the accident he refused to acknowledge his sudden incapacity, declining a wheelchair and insisting that he would soon be going back to work in the tunnels. His recovery did exceed doctors' expectations – such was the strength of will he applied to regaining his strength of body. But having regained what physical ability he could, he was still left with major injuries and progressive deterioration. Since it was beneath his dignity to 'retrain' for the menial bench work on offer in sheltered employment schemes, he was considered, in the impersonal parlance of industrial injury classification, 'a total wreck case'. Unsurprisingly, with his growing despondency and resignation to his reduced state, John Landy has increasingly withdrawn from the world. He has always kept a car – that great symbol of mobility – and he occasionally turns over the engine, but no longer drives it anywhere. He moves between his bedroom and the dining room, from his bed to his chair, spending long periods asleep, or resting, periodically shaken to life again by bouts of coughing and involuntary nerve spasms.

Not much seems to happen in the confined space of his life. And it is on this 'nothing much' that Michael Landy has decided to concentrate in this work. His mother Ethel is a key figure in this human story too. For twenty-seven years she has continued to work and

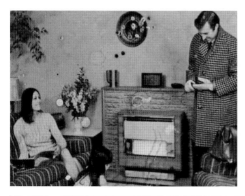

support the family through this devastation, pursuing compensation and appropriate medical treatment on her husband's behalf. The artist is clear, however, that this work is centred on his father, and so for the moment, Ethel Landy's story remains outside the frame.

The accident was a seismic event for each member of the family, and Landy is quick to acknowledge its formative influence on his work as an artist. *Semi-detached* is powerful and intimate – so much so that it might leave viewers struggling to define the boundaries between prurience and personal reflection. As we examine an artwork that presents the extraordinary circumstances of an ordinary life, we are challenged to find our own vantage point.

The installation presents the front and rear elevations of the Landy's semi-detached suburban house, reproduced to scale and using real bricks and mortar. Utterly familiar, it has the characteristic features of millions of British houses, 'modernised' with pebble-dashing, UPVC windows and doors, satellite dishes and kitchen extensions. The sense of intimacy triggered by the sheepskin coat is now projected onto the whole house – and a counterpoint is established between the complex, unique human story within and the well-maintained but anonymous pebble-dashed exterior that faces the casual passer-by.

The two elevations have been split apart, and at the interstice are a pair of screens onto which are projected images showing aspects of the interior life of the house. One screen shows *No.62*, filmed in the bedroom, dining room and garden shed – the places where John Landy passes time sleeping, smoking, reading, or doing a task such as counting out his pills (a pivotal point in the week), or massaging his feet in a foot-spa. With the aid of his cigarette paper-roller, he uses his good

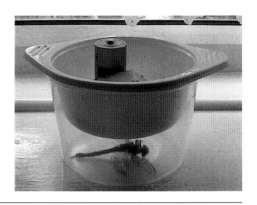

hand to make a roll-up. To smoke the cigarette, he holds it in his bad hand, which he can use only as a clamp. The camera fixes on his forearm – poised, vertical and resilient.

There is an uncertain aspect to the nature of life within this house. In this slow small world, the house itself seems to contribute its own signs of existence. The electric light on the fridge door acquires a trance-like, heightened importance. The ticking of the clock becomes a heartbeat (with a spare Energiser battery at the ready). Intermittently, the freezer hums, or the microwave bleeps. Very little moves. Very little happens. A dead dragonfly is trapped inside a Tupperware container with a colander placed on top as a lid. Puzzlingly, inside the colander is another battery. It isn't clear whether the dragonfly was captured alive or collected as a dead specimen. This dead life is mirrored in the brass Christ that hangs on the wall above the television. A piece of fluff dangling from a shelf is pictured spinning like a dervish in the air currents above a radiator. An encrusted leaf on a cobweb is silhouetted by a fluorescent light tube. The camera lingers over a wallpaper pattern with a flower and bird motif, onto which is squashed the desiccated carcass of a moth, as if the creature was fatally deceived by this representation of nature. There is a sense that the natural world has been arrested or reconstituted. Conversely, items such as the plastic-strip curtain have a living presence, as it ripples in the breeze at the back door.

Another film, *Shelf Life*, depicts the contents of a shelf in John Landy's bedroom. The shelf has an aura that seems to keep all other hands (and dusters) off it. To list the contents invokes something of their collective charge: cable clips, Sellotape and electrical tape, a vice, batteries, at least six torches, welder glue, lighter fuel, car indicator

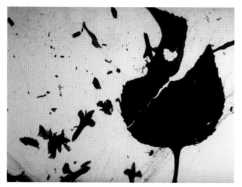
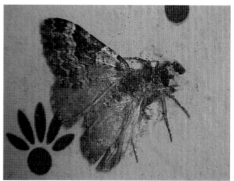

lights, dice, BluTack, Vaseline, fuses, utility-knife set, steel-wire brush set, bulldog clips, magnifying glass, heel grips, industrial ear plugs, chainsaw brushes (neatly bagged and labelled). Many items are in their original packaging, in a state of suspended newness and readiness. Pinned alongside these items are some family photographs. Whilst undoubtedly kept on the shelf for their actual usefulness, these objects also function as vital reassurances of capability: 'I can', 'I do', 'I maintain', 'I repair'.

On the reverse of the building's facade, another film, *Four Walls*, shows a rhythmic sequence of changing images derived from DIY manuals – the kind in which a handyman (though sometimes assisted by a handywoman) demonstrates the 'how-to' techniques of myriad odd jobs around the house and garden. They are drawn entirely from the stockpile of leaflets, manuals and magazines that John Landy has collected over decades, both before and after his accident. Some date from the late 1950s, when he was a young man. Others are more recent. Accompanying this sequence is a soundtrack of him whistling the tunes he loves: among them the sentimental Irish ballad 'Danny Boy', Lena Martell's country classic 'One Day at a Time', and Jim Reeves's 'Distant Drums'. Some renditions are jaunty, others are achieved with difficulty, and so slowly that the tune is scarcely recognisable. Between songs and between notes can be faintly heard a rasping, breathless wheeze.

Undeterred by the chronic limitations of his condition after the accident, John Landy has continued to accumulate not only these graphic 'how-to' guides, but also an impressive collection of tools. A chainsaw and an all-purpose Power Devil tool are kept to hand

(and in good condition) in his bedroom. Also at the ready are a plumber's grabber, WD-40, sealant, filler, slug pellets, 'easy nails', weed killer and Epsom salts. Though these are now hardly used, they remain available for odd jobs: occasionally attempted, rarely completed. In one film sequence John Landy is seen repairing an audio cassette, a Paddy Reilly tape, using super glue to stick the torn ends together. He fixes the kitchen tap. The pill container has been customised using rubber bands to aid the process of counting out pills for morning and afternoon, imposing order and efficiency. Like many DIY enthusiasts, he is convinced that since everything can serve a purpose, nothing should be junked. Even the earphones for the defunct Walkman that Michael owned at the age of eighteen are kept for potential re-use.

On a broader scale, in this, as in much of his work to date, Landy is exploring the meaning and value of labour. In his earliest video work, *Appropriations* 1990, he observed the immigrant Cypriot grocers of Camberwell in their morning routine, setting out their fruit and veg in pavement displays. This was shown within *Market* 1990, in which he presented the collapsible steel frames of the traders' stalls, the stacks of plastic crates and fake grass used to sell produce in both markets and corner-shops alike. In *Closing Down Sale* 1992, at the brink of the early 1990s recession, Landy satirised the bourgeois activity of buying and selling art by applying the sales techniques of the discount store to the 'high' commerce of the art gallery.

In *Scrapheap Services* 1995, he took a scathing look at the idea of 'useful employment'. While on the dole, and deemed unproductive, Landy was subjected (as his father had refused to be) to 're-training programmes' and was interviewed for supermarket jobs by

 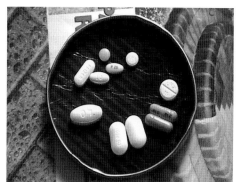

Department of Social Security officials. With Thatcherism in full swing, against a background of corporate down-sizing, mass redundancy, and privatisation of state-owned industries, he showed entrepreneurial initiative by inventing a bogus company to employ himself. *Scrapheap Services* was a company for disposing of people who were no longer useful to society, whose brutal slogan was: 'we leave the scum with no place to hide.' Landy took another hard look at post-industrial society in *Break Down*, where, in order to effect the disintegration of his possessions, he devised a 'de-production line', operated by a labour force of 'operatives' and mechanics working under his supervision, all dressed in matching blue boiler-suits. In its construction and function, his dis-assembly line aped the unceasing motion of production.

Seen in the light of the artist's long-standing concern with the human side of labour, what does *Semi-detached* have to tell us about the wider relationship between work and worth? Just as *Break Down* directly addressed the question of what composes a life, this new work brings that question to bear on the linear, cumulative narrative of the life of a traditional working-class man, whose most vital location of identity has been abruptly removed. In one moment, he lost the certainty of 'this is what I do', and therefore of 'this is who I am', and 'this is why my life matters'. In this, John Landy's life stands for all of our lives, except that for the most part, we dare not examine it.

Beyond the calamities of industrial accidents, something of the same experience of dislocation is increasingly common in today's 'flexible labour markets'. Richard Sennett writes in *The Corrosion of Character* (1998) about the erosion of a sense of self in the new economy of ceaseless corporate change: 'short term capitalism

threatens to corrode … character, particularly those qualities of character which bind human beings to one another and furnishes each with a sense of sustainable self.'[2] He gives the example of a group of immigrant Greek and Italian bakers whom he observed in Boston. Mixing the dough and working the ovens – though noisy, messy work – gave them a strong pride in their craft and a sense of community. On a subsequent visit several years later, however, much had changed. The bakery business had been sold to a giant food conglomerate who had introduced specialised, highly calibrated machines that did all the work by themselves. The solidarity of the old workforce had disappeared with the introduction of a flexible, contract-driven structure. Gone too was the physical contact with the materials, as computerised baking put on-screen icons in front of workers instead of flour and yeast. This loss of hands-on knowledge and human craft brought a loss of motivation and satisfaction. While business-speak exhorts us all to 'move with the times', and accept the flux and spontaneity of the new workplace, for many – especially those lower down the system – this represents a severe loss of dignity.

 Against the insistent market cry of 'everything must go', amid such fragmentation and dislocation, can the individual preserve a sense of indissoluble self? Seeing the contents of John Landy's shelf, and his trance-like state of mind as he smokes his cigarettes, a bizarrely ahistorical association comes to mind: the rapt St Jerome in his study, as depicted in a woodcut by Dürer. In this shallow room, Jerome's shelves are stacked with pots and candlesticks. On the wall hangs an hourglass, a crucifix, and a broom stowed neatly in its bracket. Beside Jerome is a stack of books. Ordered, but without

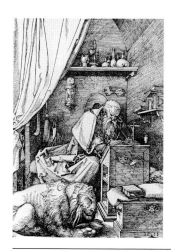

hierarchy, the implements create an aura that is at once domestic and devotional. Cheek by jowl, they convey a strong sense of temporality. Mind, body and spirit all merit daily attention. John Landy's shelf of objects, the things in the world that he keeps closest to him, are similarly both the stuff of the everyday and of the spirit – symbols that attest to his sense of purpose as a doer, and to his value as a human being, in the face of his diminished capacity.

 The Human Condition, a book by Hannah Arendt first published in 1958, offers a searching exploration of the contrast between what she calls 'labour' and 'work'. Defining labour as the unending repetition of tasks we do just to live, and work as the production of objects that outlast us, her analysis of the significance of fabrication also bears on Michael Landy's concerns. Arendt distinguishes the 'work of our hands … from the labour of our bodies' – *homo faber* who makes and literally 'works upon' is distinguished from *animal laborans*, whose labour is part of biological existence. The work of *homo faber* results in fabricated objects,[3]

 the sheer unending variety of things whose sum total constitutes human artifice. They are mostly, but not exclusively, objects for use and they possess the durability Locke needed for the establishment of property, the 'value' Adam Smith needed for the exchange market, and they bear testimony to productivity, which Marx believed to be the test of human nature. Their proper use does not cause them to disappear and they give human artifice the stability and solidity without which it could not be relied upon to house the unstable and mortal creature which is man.[4]

'I make', and having made, I am surrounded by the products of my work. And both the craft of making and the objects made serve to give permanence and definition to my sense of self: to 'I am'. In Arendt's terms, labouring leaves no trace, and therefore cannot help to give form to fluid identity. But digging a tunnel, or baking a loaf, or even mending a tape, leaves evidence of our passing, and makes us solid.

Arendt's distinction takes us some way towards understanding *Semi-detached*, though the categories cannot be neatly drawn. If the labour of the tunneller can be seen as part of the churn of human survival, it nonetheless also results in a lasting construction. The categorisation is unimportant, but the framework is relevant in so far as it assigns significance to our relationship with objects beyond property or sentiment. The tools and objects with which John Landy surrounds himself are more than the totems of a diligent householder. They go further; they go to the core of Landy's subject – what Arendt describes as the 'reification' of existence: 'The objectivity of the world – its object-or thing-character – and the human condition supplement each other; because human existence is conditioned existence, it would be impossible without things, and things would be a heap of unrelated articles, a non-world, if they were not the conditioners of human existence.'[5] In *Semi-detached*, the flux of a precarious human existence is conditioned by the surrounding objects; the promise of durability is fulfilled through object-making and fixing. Far from being an assembly of unrelated objects, John Landy's tools, both banal and poignant, are invested with profoundly human intent.

So fundamental is our common need for this sense of fixity in the face of human transience that, in Arendt's words, 'without

being at home in the midst of things whose durability makes them fit for use and for erecting a world whose very permanence stands in direct contrast to life, this life would never be human'.[6] In fabricating this work, representing the life within this home, Landy testifies to the enduring humanity of *homo faber*.

Notes

1. Gaby Wood, 'Going for Broke', *Observer Review*, 3 February 2001, p.3.
2. Richard Sennett, *The Corrosion of Character*, New York and London 1998, p.27.
3. Hannah Arendt, *The Human Condition*, second ed., Chicago and London 1998, p.85.
4. Ibid., p.136.
5. Ibid., p.9.
6. Ibid., p.135.

Semi-detached
2004
Mixed media

Four Walls 2004
Digital video transferred onto DVD
35 minutes 43 seconds

No.62 2004
Digital video transferred onto DVD
20 minutes 23 seconds

Shelf Life 2004
16mm film transferred onto DVD
49 minutes 37 seconds

For list of illustrations, see p.78

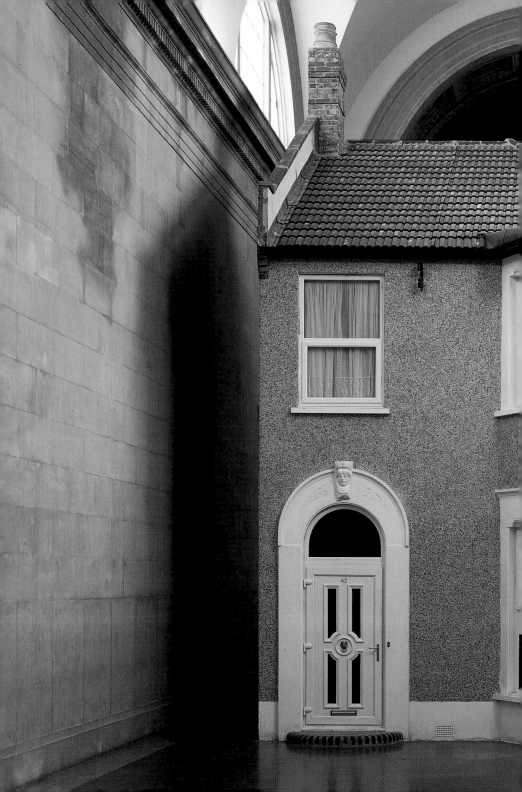

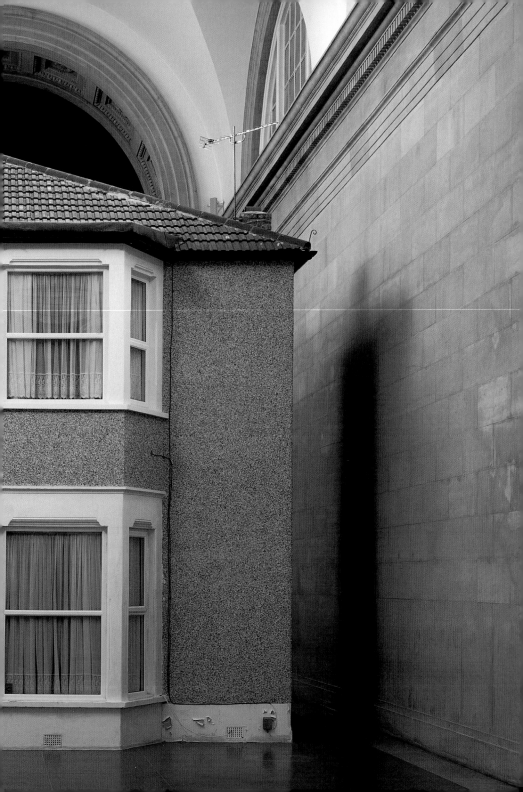

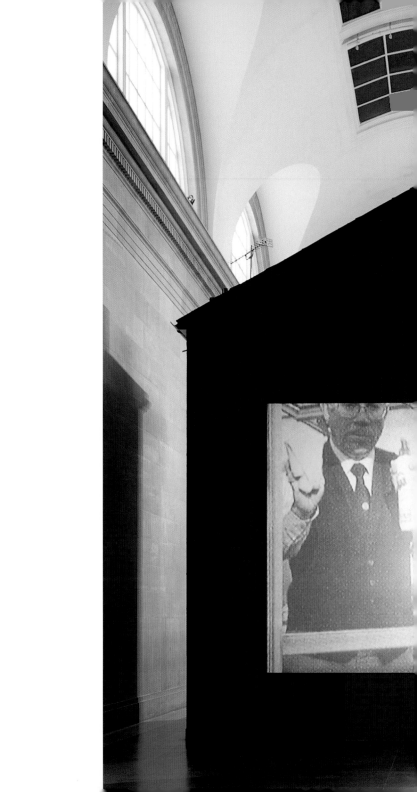

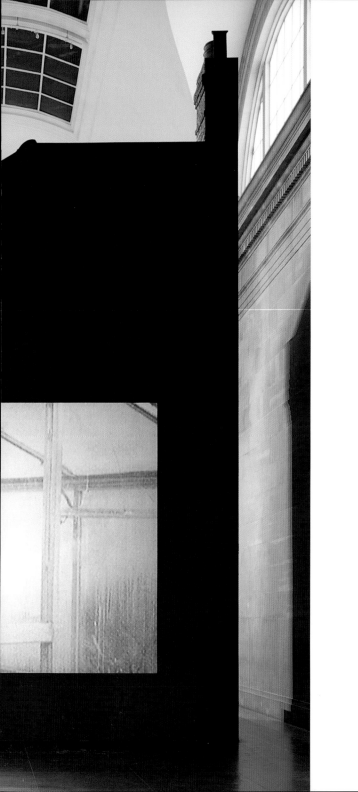

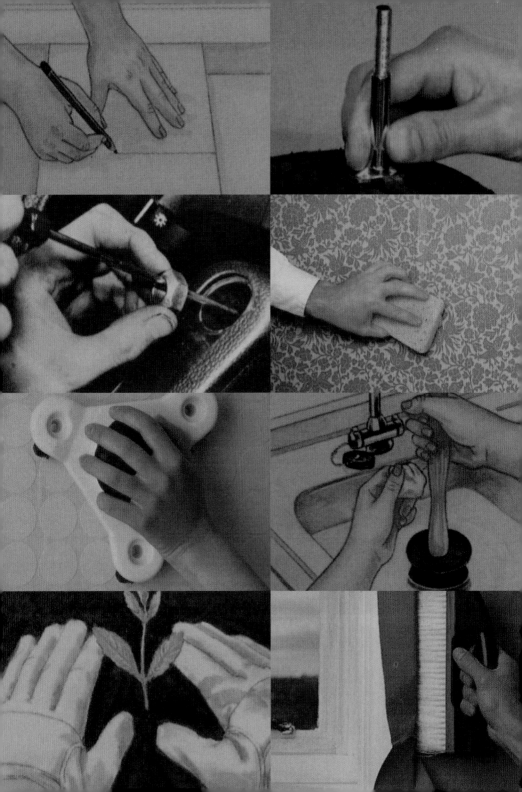

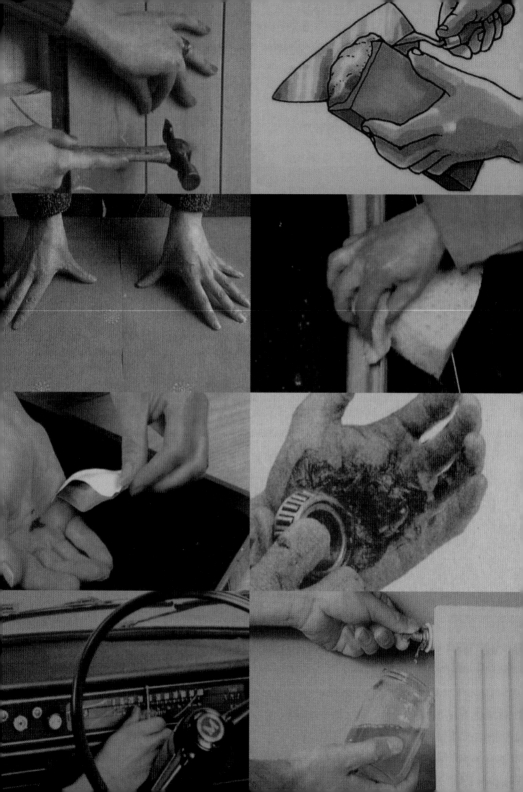

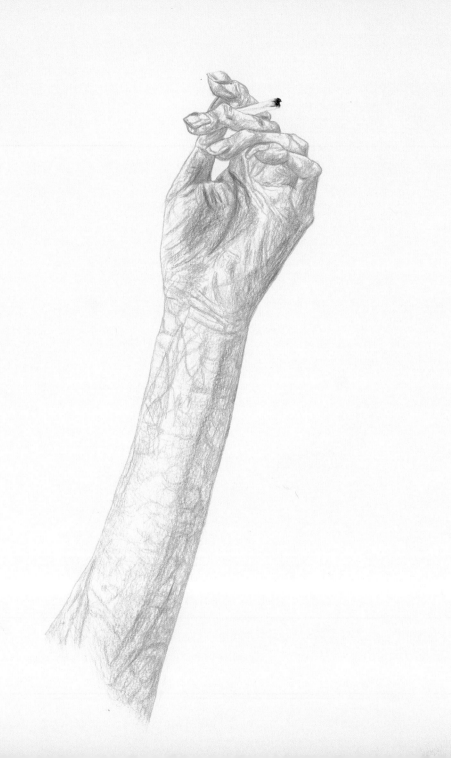

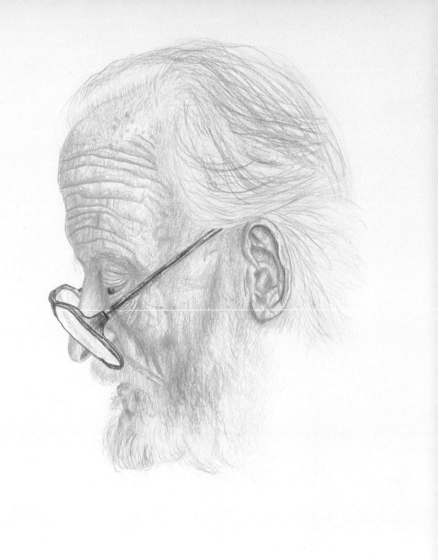

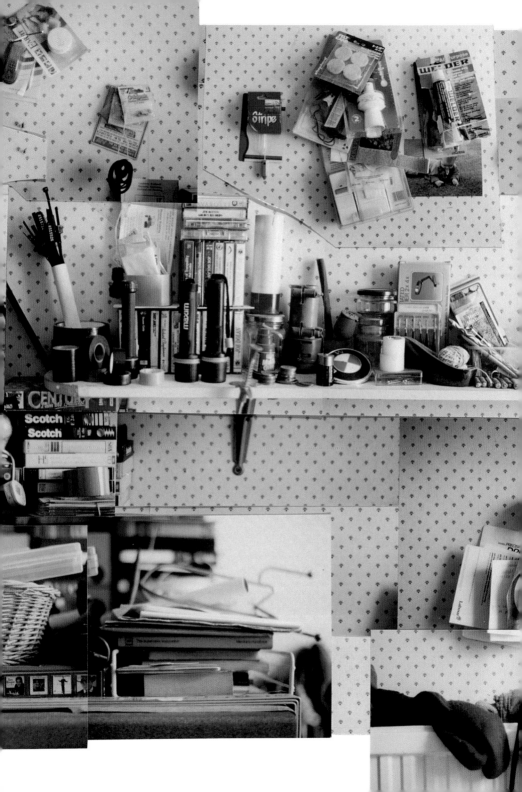

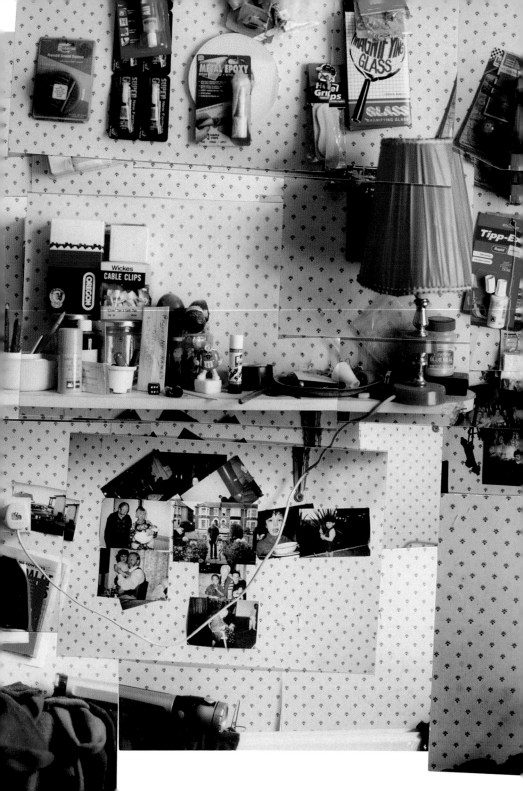

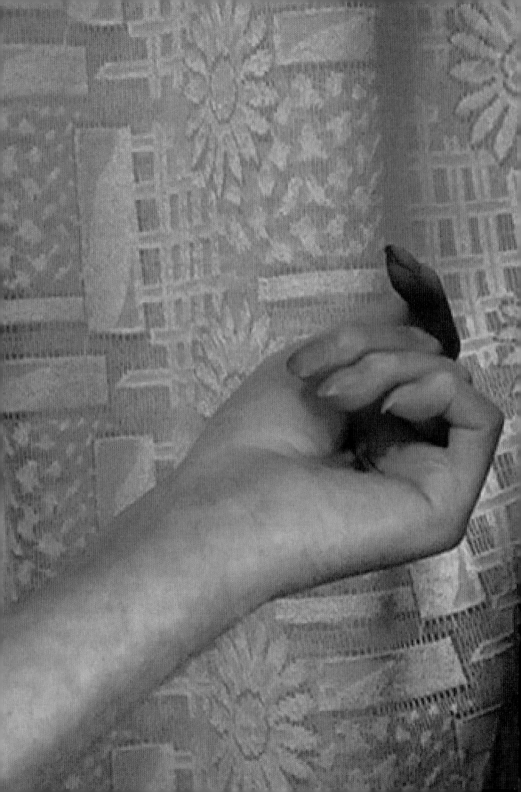

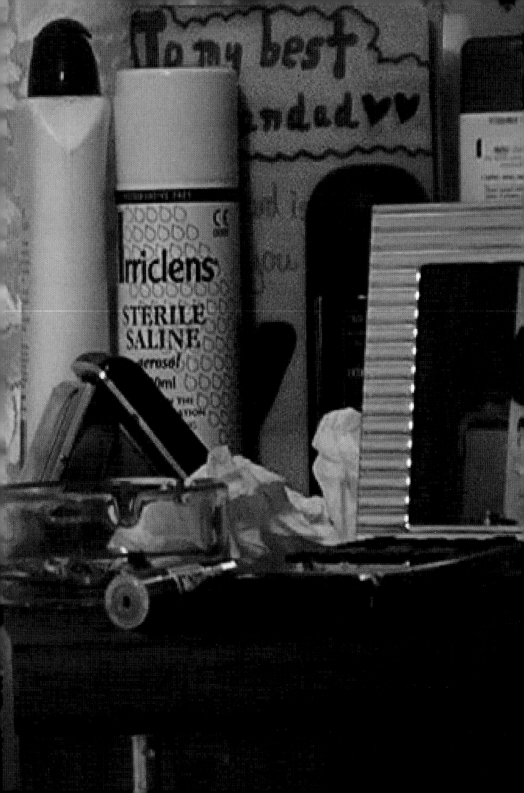

MG

BIPE

ORN

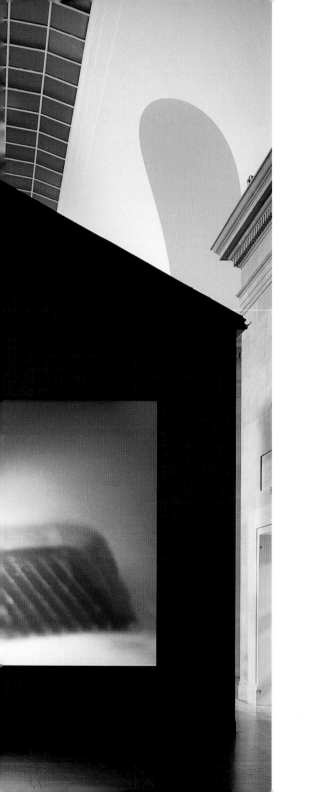

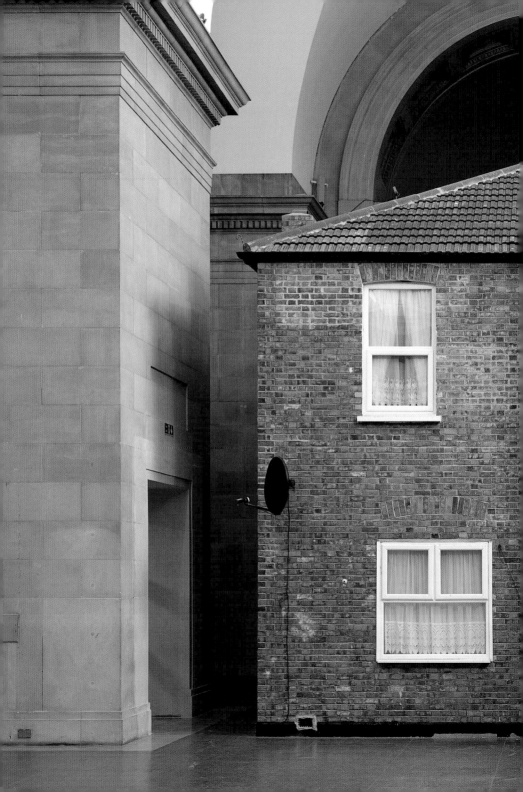

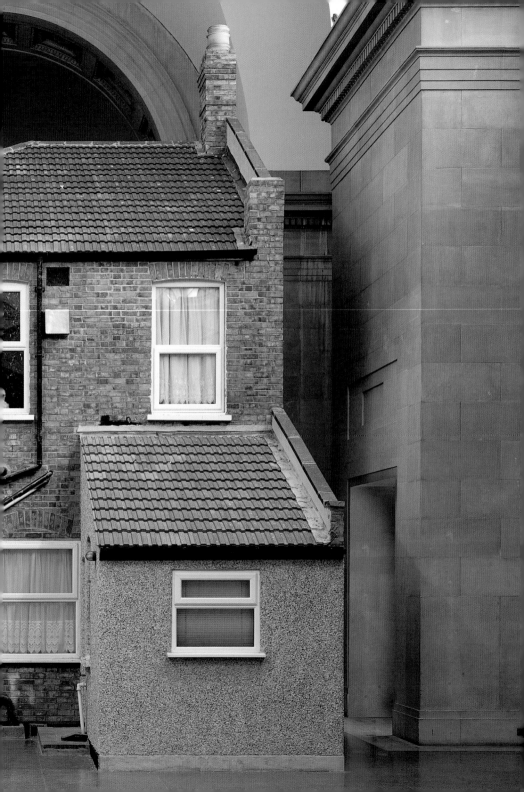

Still from *Appropriation 1* 1990

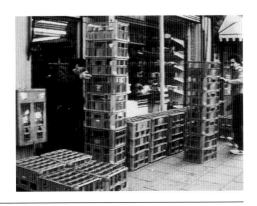

Temporary Monumental: visibility, labour, value, and procedure in the projects of Michael Landy
John Slyce

The published Inventory to *Break Down* provides the most exhaustive and elegant survey of Michael Landy's work over the last decade and a half one could wish for.[1] Any effort to compete with its index of the social relations of life, love, work and play would be little more than an exercise in stature maintenance. Instead, I want to look at four of Landy's major projects – *Market* 1990, *Closing Down Sale* 1992, *Scrapheap Services* 1995, and *Break Down* 2001 – and create something of an arc that joins my readings of issues explored in these previous works with those proposed in his current project *Semi-detached* 2004, a commission for Tate Britain's Duveen Galleries.

Temporary monumental
The title of this essay relates to two characteristics of Landy's practice expressed in the entirety of his production to date, evident even in the resolute lines of his etchings of urban weeds produced in *Nourishment* 2002. The temporal dimension of any Michael Landy project is critical. While the conception, research, development, and production of a work is inevitably extended over two, three, or four years, the actual duration of a work or the period of its visibility and presence, is always limited, relatively brief, and in terminal contradiction to the nature of the space it occupies. Whether you choose to relate to it as 'installation' or 'sculpture', Landy's art is site-specific in a sense shared by all artworks or commodities in that the meaning and identity

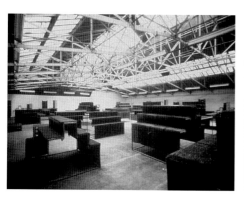

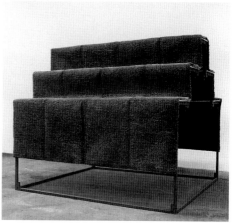

of each is, in part, shaped by the physical context and contours that surround it. His installations, however, are not presented as a response to a given space. Still, their meaning is contingent on the immediate location and surrounding social context. Shown in a disused Nabisco Factory, *Market* was a versatile arrangement of serial units in serial formation and site-specific but not embedded into the brickwork of Building One.[2] The space, though, framed *Market* in a very significant way and its previous use as a site of industrial production focused attention on the location of *Market* as well as insisting on the social nature of its production and reception. Had the hundred or so elements that comprised the work survived *Break Down*, or if they were to be refabricated, *Market* could be redeployed in another space. However, this would undoubtedly efface, if not indeed completely erode the manner in which its meaning continues to be conditioned by its brief experiential duration and fragile material existence. Michael Landy's art is one of negation – contradiction is a fundamental aspect of the way his work articulates meaning. His is a materialist practice that subverts and subordinates to itself the conditions from which it stems. Those conditions, rather than offering permanence, conservation, and extended exposure often deliver a precarious economic status for his art. The object – here today and yet perhaps gone tomorrow – acknowledges its status as an immanently tangible experience yet announces, like the voice of the barker in *Closing Down Sale*: 'It will not be repeated and it won't be seen again.'

 The second half of my title begins to describe the positive effect of his art of negation. All monuments deal in the currency of abstractions: memory, honour, nation, culture, genius, or productivity

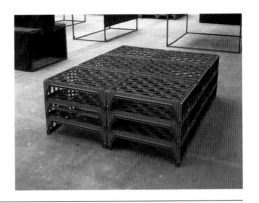

and such. Each monument, or document of culture – Benjamin reminds us – is a cover for acts of barbarism.[3] Landy's work touches on the monumental along a number of points relating to manifestations of memory and evocations of scale. An oft-recited line from Robert Smithson is apt here: 'Size determines the object, but scale determines the art.'[4] Viewers of Landy's art often comment on the monumental scale inscribed in an installation's presence. And yet, the scale of Landy's work in installation is never exaggerated in any way. *Market*, or *Break Down*, while large if viewed merely in terms of size, are each entirely within scale when considered as they relate to their targeted abstraction in the market, commodity production, or consumption. *Semi-detached* is faithfully sized in a 1:1 ratio to the original family home in Essex, and yet I can easily imagine how its scale will be magnified and details enhanced by the surrounding neo-classical monumentality of the Duveen Galleries. Smithson goes on to write: 'A crack in the wall if viewed in terms of scale, not size, could be called the Grand Canyon. A room could be made to take on the immensity of the solar system'.[5] The expansive scale of such an experience is contingent not solely on the beholder's imaginative projections, but perhaps even more in a consciousness of the generative actualities of perception which include, yet transcend, the eye and ear. My copy of Landy's *Inventory* is inscribed with words that were something of a mantra for the artist during the conceptualisation, development and execution of *Break Down*: 'A commodity is an ideology made material.' *Market* had to be the scale of an actually existing market in order to make possible the conditions in which one could negotiate one's physical role within it as both art and a market. The temporary, though monumental experience

Details from *Closing Down Sale* 1992
Karsten Schubert, London

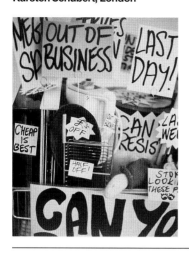
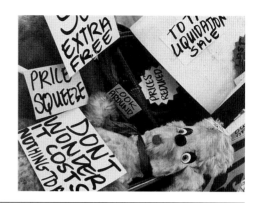

of Michael Landy's art resides in its uncanny ability to make an abstraction material on a human scale. That the work does so from within the point of view of installations awesome in their ambitions and potential for success, but also immanently fragile when considered against a backdrop of the surrounding social and institutional forces, is all the more remarkable. This amounts to more than mere timeliness, or the half-measure of blurring boundaries presumed to exist between art and life. The scale of Landy's achievement derives from work that is public in its practice and spirit and, at its best, reveals the art process as a social practice grounded in an art world that is never a world apart.

Visibility
Landy's projects often start in the margins of a blank piece of A4. The drawings gathered around *Scrapheap Services*, *Break Down*, and now *Semi-detached* function to generate supporting capital as well as clarify ideas. The large wall drawing Landy created for the show *Run For Your Life* at City Racing in 1993 is an exploded view of the densely packed pictographic line these works have frequently followed. Looking at an installation shot, I can recognise seeds if not indeed the germination of *Scrapheap Services* and even the prefiguring of elements from *The Consuming Paradox* 1999 and *Break Down*. Also visible are elements from the continuous flow of fragmented imagery that constitutes the material marginalia of the everyday for his father John Landy, as depicted in the video components of *Semi-detached*. Some thirty drawings were produced to support *Scrapheap Services*, materially and conceptually, and the arrival of this production marked a return to the medium.

Drawing sustained his practice during a period when Landy was developing what would become *Break Down*. In the show he put together in his then studio/loft at 7–9 Fashion Street – *Michael Landy at Home* – seventeen drawings were shown on a series of stackable milk crates deployed in banks of yellow, blue, green, red, and orange. Acting simultaneously as supports for drawings, podiums, platforms, individual units and collectively forming a whole that denied any art commodity status, the milk crates carried this warning: 'The Sole Property of Michael Landy who will Prosecute for the Retention or Unauthorised Use of this Crate.' Referring via the crates back to a moment in *Market*, the space was domestic (complete with cat and TV) but also a site of production where Landy stooped over the sprawling *Consuming Paradox* and collaged bits of research into his own consumptive/productive lifestyle.

Much of Landy's work originates from within the autobiographical. At times more or less apparent, this source nearly always gives way to larger experiential identifications as one's attention shifts from the work and author and onto its wider frame. Landy pays special attention to the site, forms of address and audience in the conceptualisation and execution of a project. The most substantial measure of a work's success resides in its ability to transcend the producer's subjective identification with the content and offer a visual experience of a social abstraction. *Scrapheap Services*, over three years in the making, was to a significant degree a DIY exercise in job creation for the artist. Yet its power lies in the way it redounded against Thatcherite denials of the existence of 'society' and the social cost of the human detritus left in the wake of leaner margins of profit and a

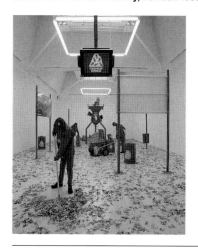

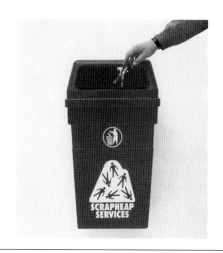

rolling back of the welfare state.[6] As in *Scrapheap Services*, the earlier *Closing Down Sale* drew on lived experience projected onto the screen of a wider socio-economic context shared with a viewer. This is a sample of the audio portion of the show that greeted visitors to Karsten Schubert's gallery on Charlotte Street in 1992:

'Cos you walk in here sad, we'll send you out smiling – bow-legged, knock-kneed and knackered with bargains. Yes, we're mad! No, we're not joking! We're so cheap here today, Ladies and Gentlemen. We're saving you cash, we're saving you money. It doesn't take a lot of working out. Bear in mind, you are under no obligation to buy, no obligation to spend any money here today. Have a look round please. Everything must go! Everything has been reduced and everything is at a fraction of normal shopping store prices. Don't believe me – I'm one of the world's greatest liars. But if you like, step inside and let your eyes be your guides, your pocket is your judge, and your money the very last thing you part with! We said we would treat you and by golly! by George! Treat you we jolly well will. For today and today only we're going to clear them out of the way. That's right Ladies and Gentlemen. So, step inside and have a look around please. Crazy, Crazy, Crazy, Crazy, Crazy, Crazy! A lady came up to me a moment ago and she said to me, 'Young man, how can you sell it so cheaply?' I said, 'It's very simple, you see – it's a massive sale, it's a monster sale, it's a £100,000 clearance sale.' So, step inside! Do yourself a favour and everyone will get a bargain here today. Bargains, Bargains, Bargains! If you're 5, 15, or 60–6, 16, or 66 we said we would treat you and treat you we jolly well will. Don't be shy 'cos I was shy when I was a little girl and look at me now.

Detail from *Integrated, Dismantling, Sorting and Separation System* 1998
Courtesy of Jeremy Lewison Ltd

Too late, too late, will be the cry when the bargains you've wanted have passed you by. Bargains, Bargains, Bargains! So, step inside. They will not be repeated and they won't be seen again.

The large plate-glass windows to the front of Karsten Schubert's space once served to display the wares of a shoe store. Here they were bedecked in apocalyptic whitewashed slogans that mirrored those of the manic and increasingly frantic barker: 'Recession Smasher', 'Everything Must GO', 'Stop! Look At These Prices!' As sequel to *Market*, *Closing Down Sale* filled a space to the brim with product that was only suggested by its absence in the precursor, thus making evident the mercantile nature of a gallery. What was still referred to then as the 'World Economy' was locked in deep recession and the art market – always narrow and international – had by necessity followed suit.[7] The items that filled the shopping trolleys were beyond redemption, broken, and festooned in DayGlo tags. Landy had culled the majority – from sad teddy bears to piss-stained mattresses and broken turntables – through daily trawls in housing-estate bins. We know intuitively that such materials and procedures, along with their placement or location, are inscribed within the conventions of language and thereby within institutional, ideological, and economic power even when we may outwardly deny any knowledge of the case. We refer to a gallery as a 'gallery' and not a shop even when we know that the wares on display are for sale. A museum may be far removed from a department store, but how distant are our experiences or modes of attention in each? *Semi-detached* is a representation of a house and its material culture located within the halls of a palace of culture. A question one may ask

Detail from *Compulsory Obsolescence* 2002
Government Art Collection

Michael Landy at Home 1999
Installation view

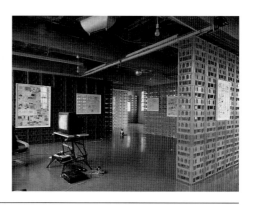

there is, 'who and what is alive and at work in each?' Part of the bargain offered in *Closing Down Sale* and available across Landy's projects is the opportunity imaginatively to construe these kinds of questions and their often-simple truths.

Labour

An apparatus is the system or structure in which a process occurs or an organisation functions. *Market* explores, through its physical installation and *Appropriation* videos, the apparatus of display alongside its attendant and ritualistic labours. *Closing Down Sale* treats the apparatus of the sale within the heightened social context of a recession. *Scrapheap Services* and *Break Down* turn to an apparatus of production, consumption, and recycling of labour in and as a commodity. Labour and its value are processes whereby social relations between people assume a particular material form. That this form is only ever reflected in the magic house mirror of a commodity means its image is always already distorted, partially hidden, often effaced, or indeed invisible. As their labour is threaded through the apparatus of the market, artists are estranged from their production. In no way in control of his or her 'value', an artist's 'work' can become production for production's sake. Labour, in Landy's projects, can be read as something of a melancholy process. But at the same time, work and labour affirm what identity can cohere around, what is in essence, a void at the centre of any subject. Partly an event with elements of actual or suggested performance, each of Landy's projects is a materialist analysis of the mechanics, or apparatus, of the world we live, love, and labour in. One's identity can only ever really come together within a

community. We each struggle to be recognised through the forms we inhabit – our bodies – and the forms we create – our work. Confirmation, when it comes, therefore stems from within an intimate network of bodies, subjectivities, labour, and its product, which form a community. By reversing the constructive processes of labour and identity, *Break Down* analysed succinctly how the consumerist commodity attempts to supplant community in late capitalism.

 Work on a new project has nearly always, at least before *Semi-detached*, begun during periods when Landy had no tangible budget or even an outlet for a work. The minimal and repetitive labour of making the thousands of die-cut figures featured in *Scrapheap Services* took on the form of bench-work – a fate nearly worse than death to a skilled artisan or worker familiar with the exhilaration and self-authored valour of exacting physical labour. This pattern of labour was also evident in *Break Down*. In many ways unique, *Semi-detached* is Landy's most autobiographical work to date. Yet, its autobiographical content, while still projected onto a wider social screen, is at the same time refracted in the biography, body, and relations to work and labour of his father, John Landy. Known to anyone who witnessed something of *Break Down*, his father is indelibly associated with either the sheepskin coat – the last of Landy's possessions to be destroyed – or the Jim Reeves's rendition of 'Old Tige'. John Landy is Michael's father and yet John Landy is also every man or woman who has been injured or broken by industrial labour. *Semi-detached* would not be materialising here and now without the institutional support of Tate Britain, but then Michael Landy would not likely have come to this material if not for the psychological conjuncture

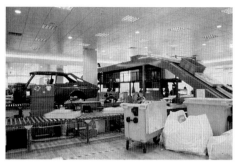

that was *Break Down*.

 Landy was incredibly vulnerable during and after *Break Down*, but also suddenly free of illusions and the weight of his past. If we can ever imagine a point of non-identity, it would feel something like the moment before he picked up the phone and ordered a new Switch card, or attempted to get a new birth certificate and began to rethread himself through the apparatus of the state. Landy didn't consider any new work for over a year. And after working intensively on the weed etchings, he sublet a small studio in the same area of Hackney where his family had lived before moving to Essex. In June of 2003 he began shooting what is now over 110 hours of video footage of his father and the everyday marginalia of the family home that constitutes John Landy's world. This material depicts an economy of time that is other than the routinised and administered flows we are each enmeshed in.

Value

 Through words, a slow image begins to form – it's one of stasis and entropy, where communication falters and one day drifts on seamlessly into the next. Everything is very still in the house – there is no great dynamism. A clock ticks, a fridge-freezer light flickers and hums in the dining room and one is suddenly transported to somewhere else. Textures are animated by exacting details produced as much as recorded in the slow panning of a camera across a shelf. Time takes on a physical presence measured in the creeping deterioration of an edifice. In talking to Landy about the process of bringing together the images, materials, and ideas that will finally coalesce as *Semi-detached*, my mind returns to *Break Down* and its working day real-time industrial

E1029	MK three-way three-pin white plastic plug socket
E1030	Braun Silencio 1200 black plastic hairdryer with electrical flex and three-pin plug
E1031	Black plastic aerial from Clive Lissaman's Nokia mobile phone that was bitten off in Muhib Indian Restaurant, Brick Lane
E1032	Draper blue plastic-handled soldering iron
E1033	Four-socket 13amp white plastic extension lead with power supply red light and three-pin plug on 2 metre electrical flex
E1034	Turquoise rubber washer for Braun Oral B Ultra toothbrush
E1035	Psion Siena organiser with solid state drive and adapter, purchased from Leonie Lupton
E1036	Maglite 12" black metal torch with batteries inside, purchased at Silvers, Commercial Street
E1037	Small white metal clip-on perforated lamp and on/off switch on electrical flex and three-pin plug
E1038	Purple Nintendo Colour Game Boy CGB/001 with game cartridge *Rug Rats*, present from Gillian Wearing after breaking elbow
E1039	Sony RM841 remote control unit with mauve love heart painted on it in nail varnish
E1040	Sony KV/27RTU Trinitron 26", stereo grey plastic colour television with broken control panel, purchased second-hand
E1041	JVC Nicam Digital VHS Video Cassette Recorder HR/J745EK, swap with Gillian Wearing
E1042	JVC Multibrand battery-operated plastic remote control unit for JVC Nicam Digital VHS Video Cassette Recorder HR/J745EK
E1043	Silver Sensor Hi Tech TV metal aerial on black plastic stand
E1044	Small black rubber armoured torch with blue cord

frame. Over those two weeks in February 2001, *Break Down* reproduced the idiom of work and the conditions of the workplace through actual and routine labour, and importantly, through banter and jokes exchanged between the operatives as they worked on the production line. To what degree do we learn the value of work and rhythms of labour along the same lines we acquire language and absorb its structures?

Landy read through his father's medical records during the year he has been working on *Semi-detached*. His father was written-off as a loss, deemed to possess no potential labour value and so consigned to a bedroom and dining room chair for the next twenty-seven years of his productive life. How many of us are satisfied or even willing to participate in work merely as workers? At what point do our aspirations as workers – the subjective value we place on our own productive activities – deviate and depart from those ideals and norms generated by the apparatus? To what degree are our aspirations produced and reproduced by that self-same apparatus with its own structure and system of value? These are questions posed throughout Michael Landy's major projects and in the practice of his art of negation with its troubled product and elusive object.

Procedure

The ultimate value of a work of art or indeed a life, if treated as an event or temporal process rather than a discrete object, cannot be figured in the standard columns of a balance sheet. *Semi-detached* will exist as an installation for longer than most of Landy's works. But it too conforms to a practical logic that runs counter to that of an institution. The bricks and mortar, two-by-fours, and roofing

 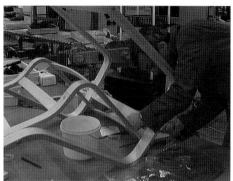

tiles may or may not be recycled – rarely does recycling actually make any commercial sense. Remnants may even find their final resting place alongside the tons of granules from *Break Down* in that same Essex landfill. If they do, it will be in keeping with my reading of Michael Landy's unwritten procedural guidelines that posit his work as an endless mediation of an irreconcilable product. The still video images, culled from the DIY catalogues and manuals that John Landy has collected since the 1950s, shown within the Potemkin structure, will survive along with its audio track. In many ways, these images of the routines of domestic labour constitute John Landy's own tenacious and stubborn procedures for creating value and dignity through a form of work.

Landy is faithful to the matter and material he works with: the bricks should be real bricks, the tiles ceramic, and the uniforms those actually worn by a company charged with clearing discarded people away swiftly and efficiently. In order to materialise the type of abstractions Landy deals in, the stuff one works with has to be real. In Landy's practice the procedures to be followed in the construction and operation of a work are specified, rather than the desired results. This is a way of keeping the potential experience of work open to allow others in and also a way of keeping it simple so that it might generate meanings that are complex. Neither is really very easy to do. If one treats everything equally – with the same duty of care and attention to detail – even banal things like bread trays, or precious things like your tools, or an aged relative or failing parent, then you are doing your job.

John Landy's job is not that very different from his son's, or yours, or mine. We are each more than the sum of our frail and failing parts, or our meagre contribution to the social product. There is

a remainder, something more in us that resists being absorbed and taken in by the apparatus. Some people use what's left over to make art, others daydream and whistle while they imagine life and its labours are elsewhere.

Notes

1. Michael Landy, *Break Down Inventory*, London 2001. The publication of this database of 7,227 items, the remains of which amounted to 5.75 tons, is a physical manifestation of memory that weighs no more than a good-sized book.

2. Once a Nabisco factory and then temporarily reclaimed as exhibition space for the group shows *Modern Medicine*, *Gambler* and Landy's solo show *Market*, Building One has now been redeveloped as a business complex and houses Keith Tyson's studio. This cycle of the social use of space, speculation, and redevelopment derives from the market and inevitably attaches itself to *Market*, thus extending its afterlife. Similarly, the former Oxford Street C&A that was the location of *Break Down* is again doing business as a department store under another corporate identity.

3. Walter Benjamin, *Selected Writings, vol.4 (1938–1940)*, Cambridge, Massachusetts 2003. 'There is no document of culture which is not at the same time a document of barbarism. And just as such a document is never free of barbarism, so

barbarism taints the manner in which it was transmitted from one hand to another.' 'On the Concept of History', theses VII, p.392.

4. 'The Spiral Jetty, 1972', in *Robert Smithson: The Collected Writings*, ed. Jack Flam, Berkeley 1996 p.147.

5. Ibid., p.147.

6. Sean Rainbird chronicles the making and exhibition history of *Scrapheap Services* in the paper '"Are We as a Society Going To Carry On Treating People This Way?" Michael Landy's Scrapheap Services 1995', *Contemporary Art in Focus: Patrons' Papers 2*, December 2002, Tate, London.

7. Given the recession and state of the art market, the stakes would appear to have been high for Karsten Schubert and his gallery, thus making *Closing Down Sale* a very real moment of 'madness'. However, the logic of the commercial gallery holds that bad economic times often give rise to the most challenging art. Good times or bad, the real business of the art world is marginality and fresh blood is an ideal product to take to a slow market.

Selected Projects

Appropriation 2 1990
Market 1990
Closing Down Sale 1992
Scrapheap Services 1995
Break Down 2001

For list of illustrations, see p.78

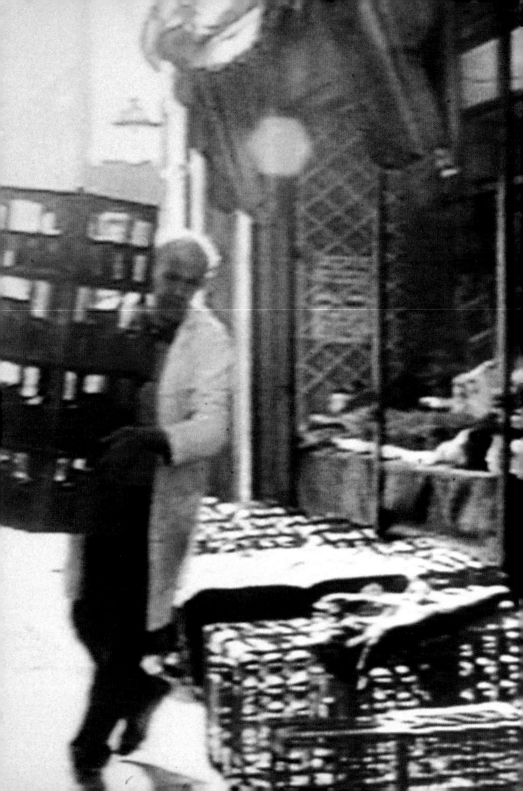

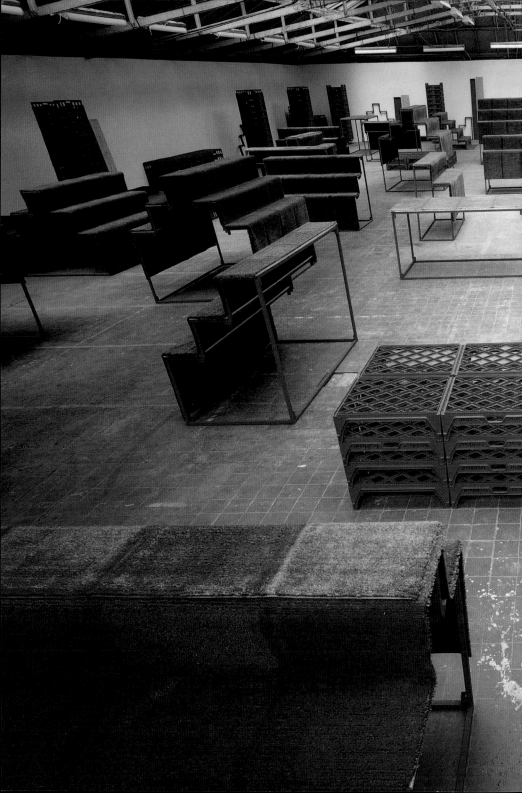

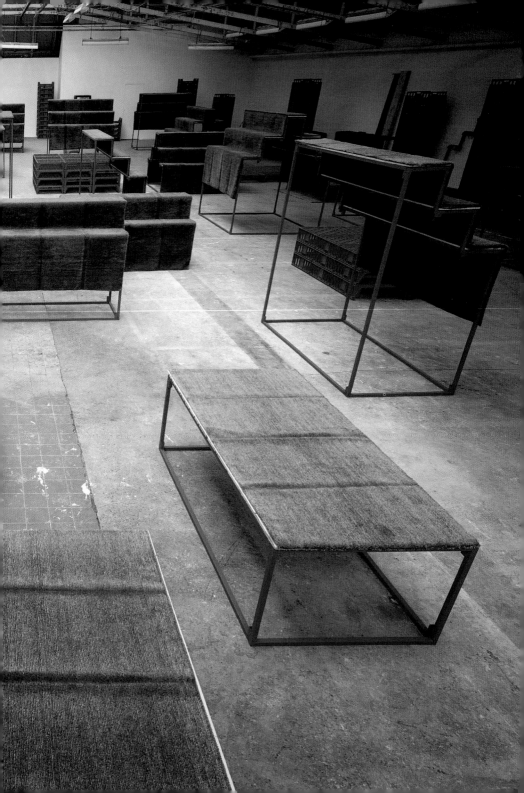

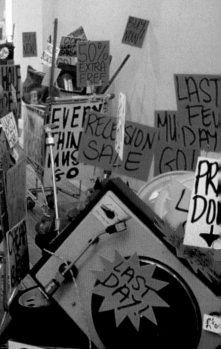
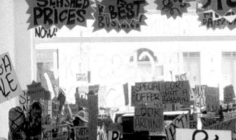
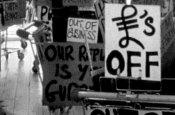

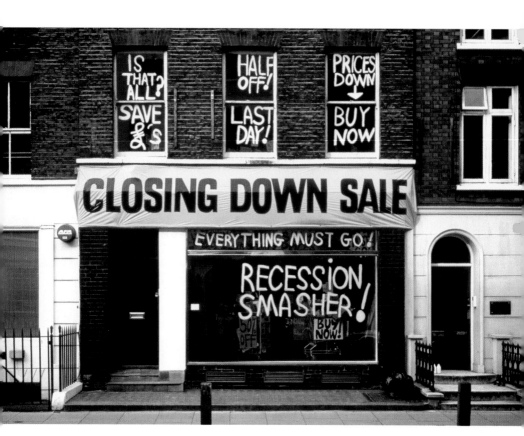

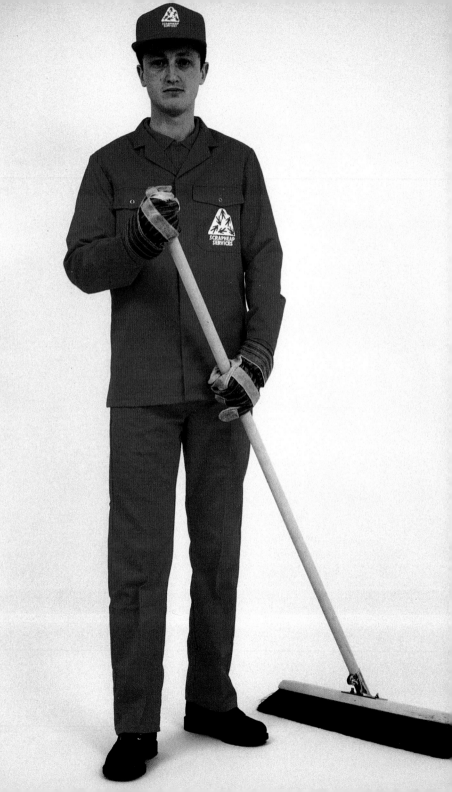

Michael Landy
1963
Born in London
1979–81
Loughton College of Art
1981–3
Loughborough College of Art
1985–8
Goldsmiths College, London

Solo Exhibitions
1989
Sovereign, Grey Art Gallery and
Study Center, New York University
and Karsten Schubert, London
1990
Market, Building One, London
Galerie Tanja Grunert, Cologne
Studio Marconi, Milan
1991
Michael Landy: Appropriations 1–4,
Karsten Schubert, London
1992
Closing Down Sale,
Karsten Schubert, London
1993
Michael Landy: Warning Signs,
Karsten Schubert, London

1995
*Multiples: Editions from Scrapheap
Services*, Ridinghouse Editions,
London
1996
Scrapheap Services, Electric Press
Building, Leeds, organised by The
Henry Moore Institute, touring to the
Chisenhale Gallery, London
The Making of Scrapheap Services,
Waddington Galleries, London
1999
Scrapheap Services, (collection
display), Tate Gallery, London
Michael Landy at Home,
7–9 Fashion Street, London
2000
Handjobs (with Gillian Wearing),
Approach Gallery, London
2001
Michael Landy: Break Down,
Artangel Trust at C&A store,
Marble Arch, London
2002
Michael Landy: Nourishment,
Maureen Paley/Interim Art, London

2003
Michael Landy: Nourishment,
Sabine Knust/Maximilianverlag,
Munich

Selected Group Exhibitions
1987
Bonner Showroom, London
1988
Freeze Part 1, Surrey Docks, London
Ian Davenport, Gary Hume and
Michael Landy, Karsten Schubert,
London
*That Which Appears is Good,
That Which is Good Appears*,
Galerie Tanja Grunert, Cologne
Show and Tell, Riverside Studios,
London
1989
La Biennal de Barcelona
Young British Art Show, Esther
Schipper, Cologne
1990
The Köln Show, Cologne
East Country Yard Show, London
1991
Michael Landy, Christian Marclay,
Peter Nagy, Andreas Schon and

Steve Wolfe, Jay Gorney Modern
Art, New York
Broken English, Serpentine Gallery,
London
1992
*Commissions and Collaborations:
The BBC Billboard Project*, Mills and
Allen, London
London Portfolio, Karsten Schubert,
London
Instructions, curated by Liam Gillick,
Gió Marconi Gallery, Milan
1993
Visione Britannica, Valentina
Moncada and Pino Casagrande,
Rome
Royal Academy Summer Exhibition,
Royal Academy of Arts, London
*You've Seen the Rest Now Try the
Best*, City Racing, London
Restaurant, curated by Marc
Jancou, La Bocca, Paris
1994
Not Self-Portrait,
Karsten Schubert, London

1995
Here and Now, Serpentine Gallery, London
LA International, Shoshana Wayne Gallery, Santa Monica
12th International Biennial of Small Sculpture, Murska Sobota, Slovenia
Brilliant: New Art from Britain, Walker Art Center, Minneapolis, touring to Contemporary Arts Museum, Houston
1996
The Meaning of Life, The Art Nolde Foundation, Stockholm
Ace!: Arts Council Collection New Purchases, Arts Council exhibition, touring to Hatton Gallery, Newcastle-upon-Tyne; Harris Museum and Art Gallery, Preston; Oldham Art Gallery; Hayward Gallery, London; Angel Row Gallery, Nottingham; Ormeau Baths Gallery, Belfast; Arnolfini, Bristol
1997
Material Culture: The Object in British Art of the 1980s and 1990s, Hayward Gallery, London

Follow Me: British Art on the Lower Elbe, organised by Landschaftsverband Stade; billboard at Kaemmererplatz, Cuxhaven
Dimensions Variable: New Works from the British Council Collection, Helsinki Art Museum and touring
Sensation: Young British Artists from the Saatchi Collection, Royal Academy of Arts, London, touring to Hamburger Bahnhof; Museum für Gegenwart, Berlin; Brooklyn Museum, New York
1998
Made in London, Simmons & Simmons in collaboration with the British Council, EXPO 98, Museu de Electricidade, Lisbon
Wastemanagement, Art Gallery of Ontario, Toronto
Trace, Liverpool Biennial, Liverpool
Purile 69, Living Art Museum, Reykjavik
1999
Flowershow, Fruitmarket Gallery, Edinburgh

2000
British Art Show 5, National Touring Exhibition organised by the Hayward Gallery for the Arts Council of England, touring to Edinburgh, Southampton, Cardiff and Birmingham
2001
Century City, Tate Modern, London
2002
XXIV São Paulo Bienal
From Blast To Freeze: A Century of British Art, Kunstmuseum Wolfsburg and Les Abattoirs, Toulouse
Shopping: Art and Consumer Culture, Tate Liverpool and Kunstverein Frankfurt
2003
Micro/Macro: British Art 1996–2002, Mucsarnok Kunsthalle, Budapest
For the Record: Drawing Contemporary Life, Vancouver Art Gallery

Publications
Michael Landy: Appropriations 1–4, exhibition catalogue, Karsten Schubert, London 1991

Kate Bush, *Market: Michael Landy*, exhibition catalogue, One-Off Press, London 1991

Michael Landy, *Scrapheap Services*, artist's book, Chisenhale Gallery, London 1996

Alison Jacques (intro.), *The Making of Scrapheap Services*, exhibition catalogue, Waddington Galleries, London 1996

James Lingwood (ed.), *Break Down*, exhibition catalogue, Artangel, London 2001

Michael Landy, *Break Down Inventory*, Ridinghouse, London 2001

List of Colour Illustrations

Photographic Credits

Additional credits to those provided in the captions:

Closing Down Sale and *Market*: courtesy Karsten Schubert/photographer Ed Woodman

Scrapheap Services: installation at Tate Gallery, Tate Photography; all other photography Mike Bruce

Integrated, Dismantling, Sorting and Separation System: courtesy Jeremy Lewison Ltd/photographer Ed Woodman

Break Down: courtesy Artangel/photographers P. Taghizadeh and Dillon Bryden

Four Walls, *No.62* and *Shelf Life:* courtesy Thomas Dane, London, and Alexander and Bonin, New York/ screen grabs by Kathy Kenny

Semi-Detached: courtesy Thomas Dane, London, and Alexander and Bonin, New York/photographed by Steve White